AROUND SPEKE

SPEKE

THROUGH TIME

David Paul

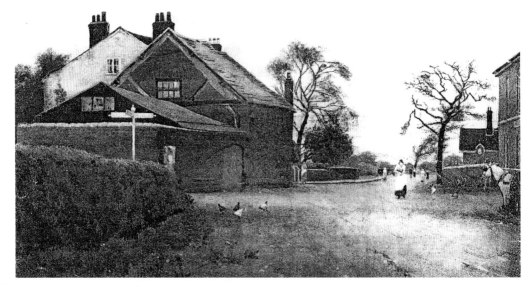

A very old photograph of the crossroads at Hunts Cross.

First published 2009

Amberley Publishing Plc
Cirencester Road, Chalford,
Stroud, Gloucestershire, GL6 8PE

www.amberley-books.com

© David Paul, 2009

The right of David Paul to be identified as the Author
of this work has been asserted in accordance with the
Copyrights, Designs and Patents Act 1988.

British Library Cataloguing in Publication Data.
A catalogue record for this book is available from the British Library.

ISBN 978 1 84868 317 4

Typesetting and Origination by Amberley Publishing.
Printed in Great Britain.

Introduction

It goes almost without saying that the only aspect of modern life which we can be certain of, is the certainty of change. Fortunately, as change within a region or a town is normally almost imperceptible, many people fail to observe the subtle changes in the built environment or even changes occurring on the High Street. Change and the reasons for change are complex and certainly very different in nature. In today's society, ecological factors are dictating change to a great extent, as indeed are societal issues. And then there are economic factors; not least of which is the current 'Credit Crunch'. This time next year, household names such as Woolworths and MFI will no longer be with us, or, for that matter, many other retailers which some of us have grown up with. The aim of this book about Speke and its environs, is to record the marked differences in the Speke of yesteryear and the Speke of today.

The format of the book, with one older photograph sharing a page with a more contemporary shot, serves to illustrate the often marked changes which have occurred over the last sixty or so years.

But first, a brief word about Speke itself. The Manor of Speke was owned by the Molyneux family for much of the thirteenth century, and then passed, through marriage, to the Norris family. In the late fifteenth century Sir William Norris became lord of the manor and started the building of Speke Hall. Ultimately, after passing through the hands of the Beaucterk family, the hall and estate were sold to Richard Watt. The Watt family owned the hall and estate until the last incumbent, Miss Watt, died on 21st August 1921.

During most of that time the manor didn't change that much, and even as recent as the late 1930s, the population of Speke village still numbered less than 400. But, when Liverpool Corporation purchased the land from the trustees of the late Miss Adelaide Watt in 1928, for the 'absurd' figure of £200,000, all of that was about to change. And, by the early 50s the population of Speke was in excess of 25,000! This 'step change' in the twentieth century has been the most significant occurrence in the whole of Speke's ancient history; changing for ever the complexion, composition and character of the village and the surrounding area.

Speke – the name is unique in England – can claim an entry in Doomsday as 'Spec'. As the village evolved, so too did the spelling of its name: 'Speek' appears in 1332, 'Speyke' in 1500 and in the sixteenth and seventeenth centuries the place was usually referred to as 'The Speke'. There continues to be much speculation as to where the name derived from; one of the more popular theories suggests that it comes from the Anglo-Saxon 'spic', denoting 'swine pastures'. The modern German speck (bacon) derives from the same source, and there is some evidence to support the claim that Speke was for many years a pig-breeding area.

At the start of the twentieth century, it was decided that Speke should become be a self-contained satellite town of Liverpool, with an 'Air Port' adjacent to it. But, because of economic necessity, and high rates of unemployment in the region, the site was used to build a 'shadow' aircraft production facility. On 15th February 1937 the Lord Mayor of Liverpool, Alderman W. Denton and Sir Thomas White, Chairman of the Speke Estate (Special) Sub-Committee, performed the ceremonial opening of the site for the proposed factory. The costs of building the factory were very high, somewhat in excess of £500,000, but the factory would be the largest in Europe, and, when fully operational, would employ over 5,000 workers.

Because of this development, the original plans had to be shelved and significant modifications made for the new Speke. But, the modified plans still included a technical college; numerous schools; a salt water open-air swimming pool; shopping centres; a public golf course; churches; cinemas; recreation grounds and a community centre, so the original concept of creating a self-contained community unit rather than a dormitory estate for occupation only by the lower paid workers could be maintained.

It's interesting to note that some of those ideas and concepts did indeed come to fruition; some will never be translated into reality, having been scrapped, for many different reasons, over the years since the new Speke was conceived; and some developments can only be classed as being 'work in progress'. Schools, churches, youth centres and shops have been built, used, knocked down and, subsequently, re-located and re-built. Whether Speke is a better place or not after a century of significant change is for the reader to decide.

David Paul
December 2008

Acknowledgements

I would wish to place on record my sincere thanks to two people in particular whose help and guidance has been of inestimable value whilst I have been researching and compiling this book; they are Ian Mowat and Lynne Moneypenny. Lynne's website, which was very informative, can be found at *www.spekeliverpool.co.uk*

Many other people gave me continued assistance, support and guidance, for which I am most grateful.

Finally, whilst I have made every endeavour to ensure that the notes in this book are factually correct, any errors or inaccuracies are mine alone.

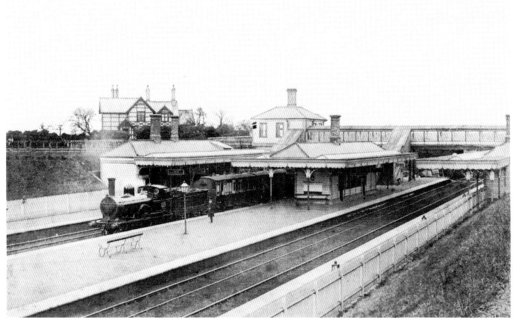

Speke Station.

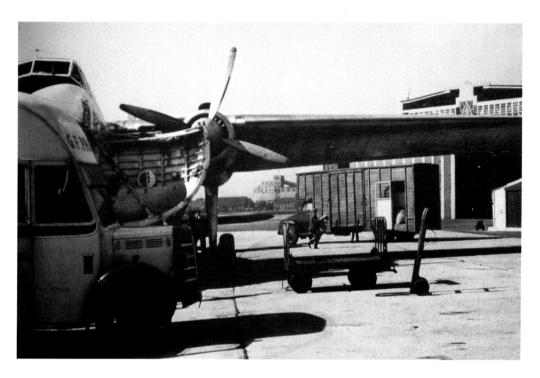

Even in 1960 there was a considerable amount of freight passing through Liverpool Airport. The Bristol 170 Wayfairer belonging to BKS Air Transport was a frequent visitor to the airport. The hangar in the background has now been converted to an up-market gym.

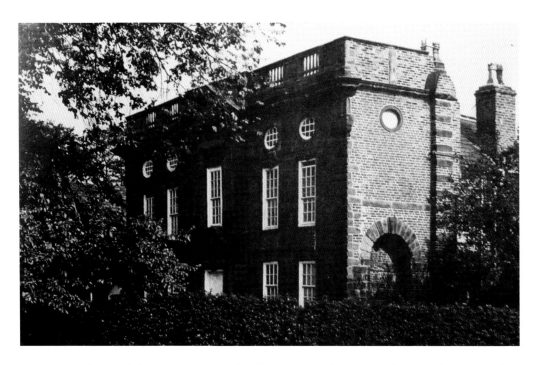

The Fleetwood-Hesketh family moved to Hale Village in 1947, but Hale Hall, where they were to live, was considered to be almost beyond repair. They took up residence in the old Parsonage House which later became known as The Manor House. Originally, the manor house was much smaller than it is today. Sometime in the eighteenth century, Rev. William Langford extended the property and added his coat of arms and monogram over the front entrance.

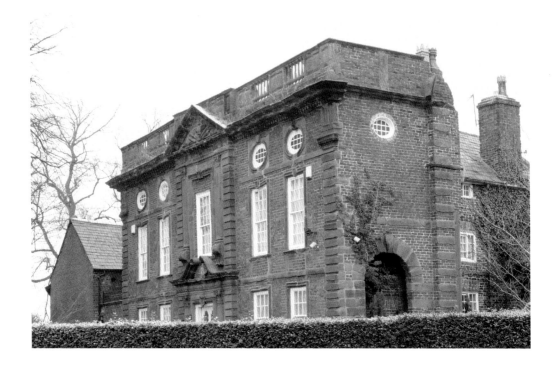

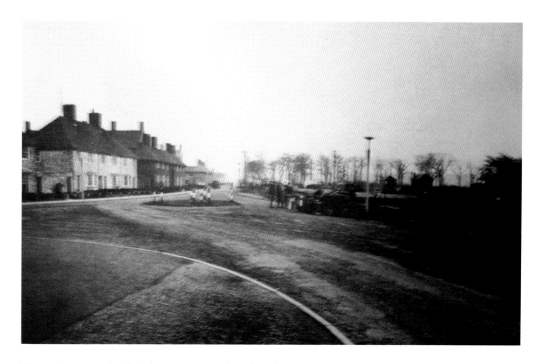

The perimeter roads of Speke were not neglected, and the improvement scheme for Hale Road was soon started. Hale Road still, effectively, marks the perimeter of Speke. In these days of low cost air travel, Hale Road has now assumed a new role, being the road that connects vehicular traffic with John Lennon Airport.

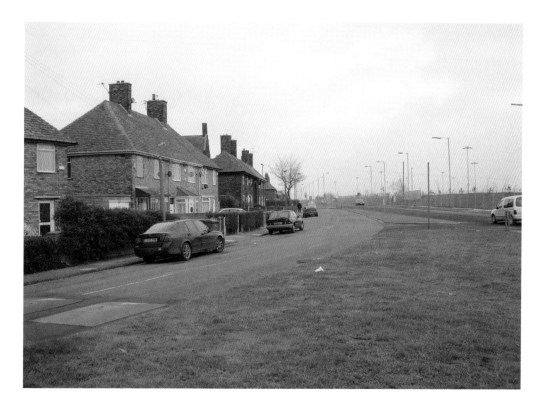

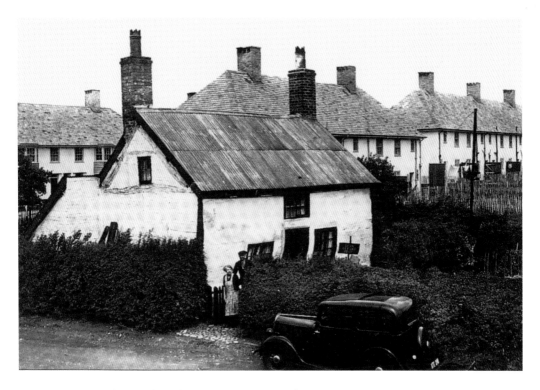

When building work started on the new satellite town of Speke, there were many cottages still standing, many over 300 years old like this one in Speke Town Lane. However, once building had started, the cottages didn't last for very long, and Speke Town Lane looks very different today.

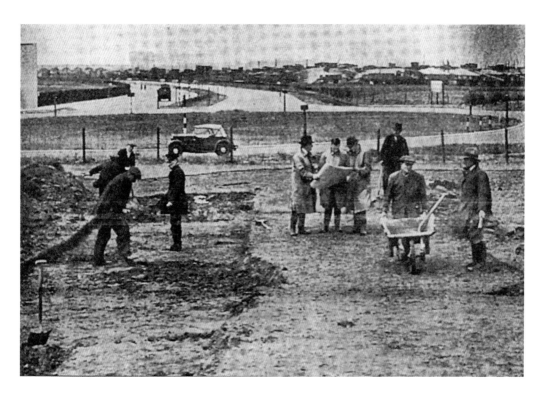

Infra-structure was the first priority when planning was completed and work on the new estate started. Speke Boulevard, which was destined to become the widest road in Europe, was one of the first roads to be completed. It carries even more traffic today!

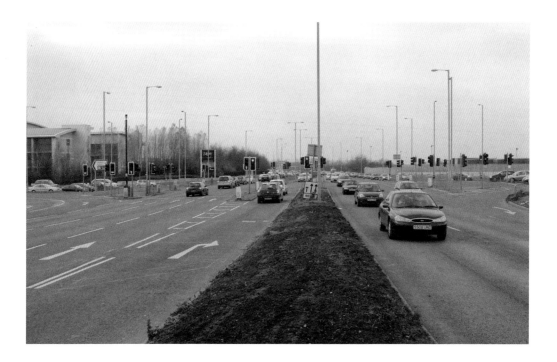

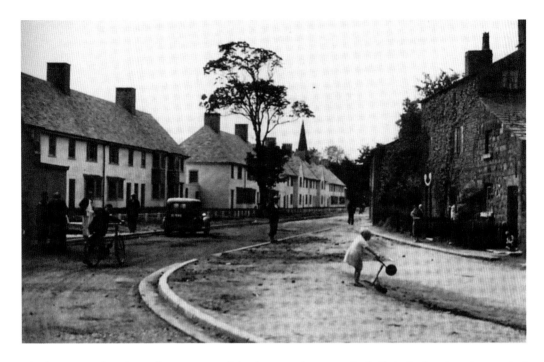

The houses in Church Road were some of the first new houses to be built in Speke; there is a marked contrast to the cottages which were still standing on the far side of the road. Some years later The Crescent shopping parade was built when the cottages were knocked down.

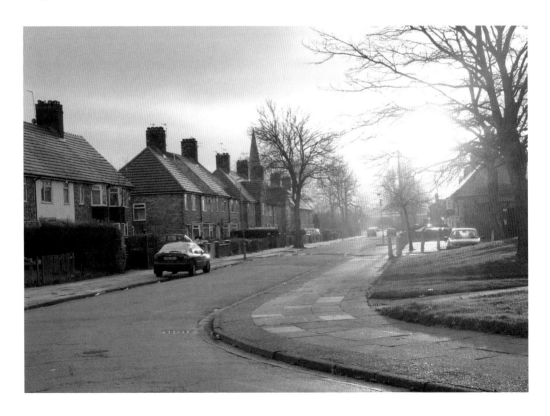

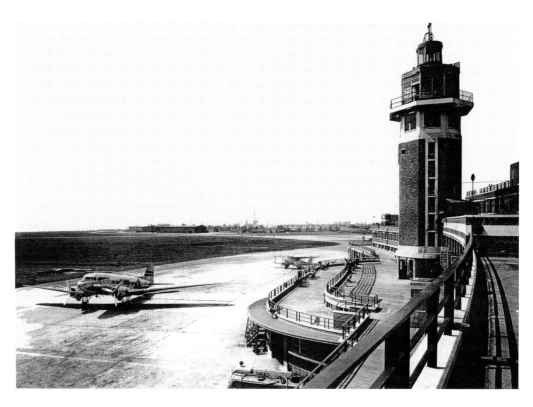

The apron and control tower of Liverpool Airport looked very sedate in 1948 when this photograph was taken. Today it still looks as sedate, but it is now a top class international hotel serving the new John Lennon Airport.

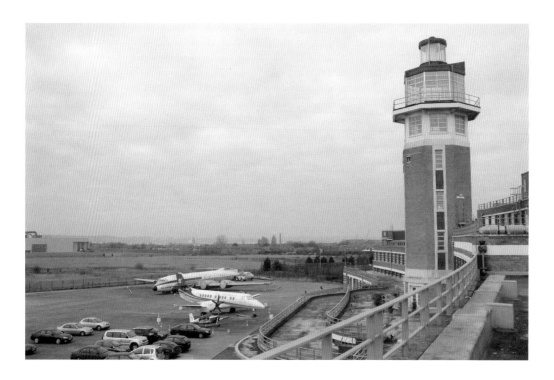

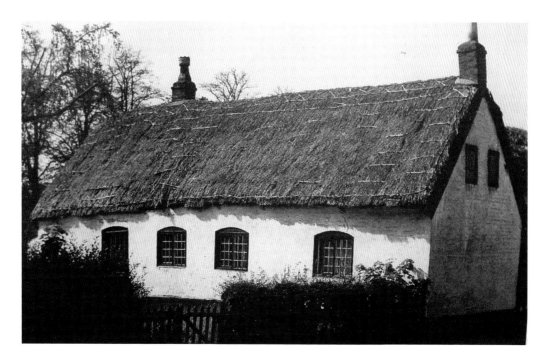

The Childe of Hale, who owned this cottage, was reputed to be nine foot three inches tall. He was born in Hale in 1578 and died in 1623. He achieved considerable fame during his life, and a life-sized portrait of him is on permanent display at Brasenose College, Oxford. He was buried in Hale church graveyard.

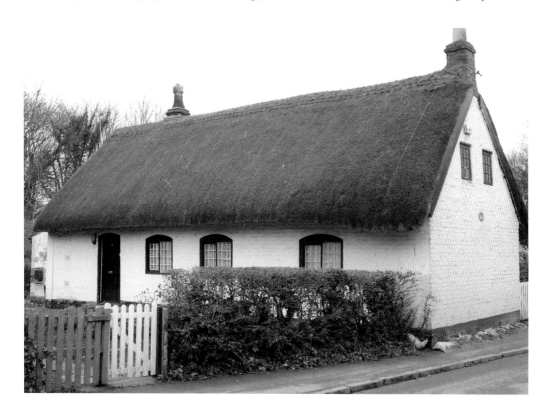

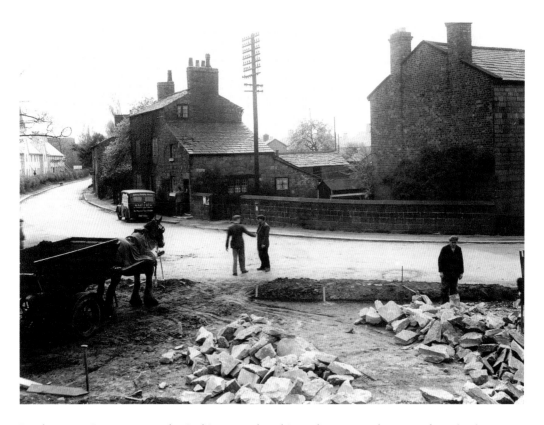

Road construction was not mechanised in 1938 when this work was started near to where the shops were to be built. It's very different now, with far more than the odd van or two passing by.

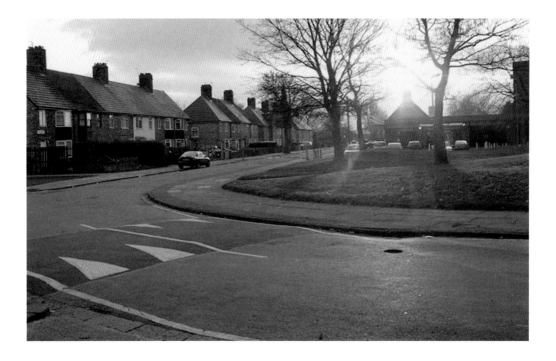

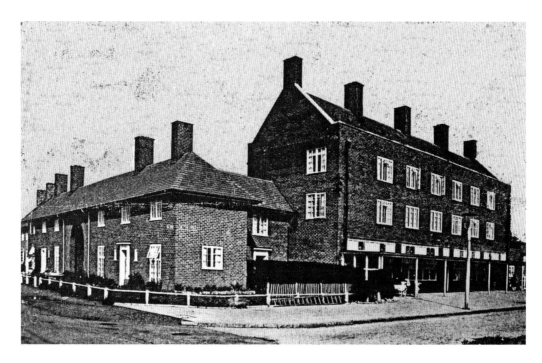

Shopping was something that wasn't forgotten, although many of Speke's residents would argue with this assertion. But, when building work was eventually started on a number of shopping centres, as they were to be known, it was envisaged that there would be a total of ninety shops, which meant that there would be four shops for each 1,000 residents. Many of the shops shown here at the bottom of Western Avenue have now closed, as shopping patterns have considerably changed in the twenty-first century.

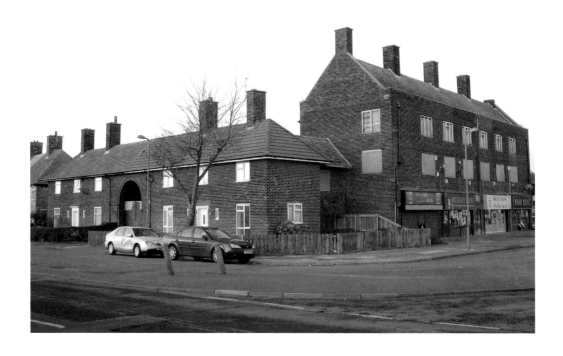

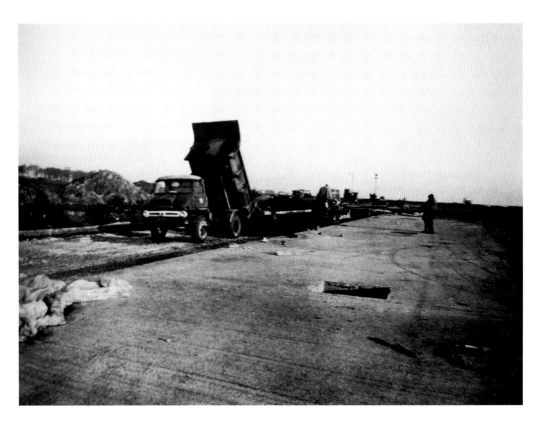

It's now over forty years since work began on the new West High Speed taxiway at Liverpool Airport. Since 31st January 1966, when the work commenced, much has changed. The airport is now known as John Lennon Airport, Liverpool, and there is much more traffic because of low cost carriers such as easyJet.

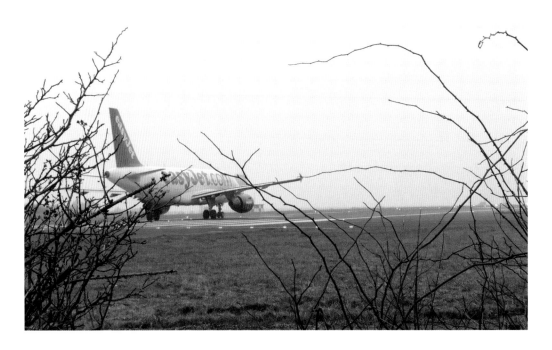

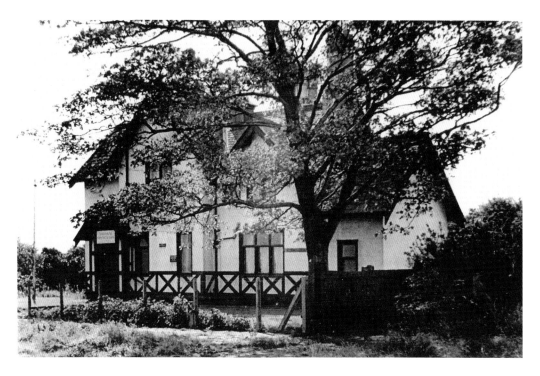

The old parsonage in Woodend Lane afforded direct access to All Saints church for the vicar of Speke, and the nearby Speke station meant that the vicar and his family could enjoy rail travel whenever it was necessary. In fact, the vicar's wife is reputed to have said that, very often the trains would wait for them if they knew that the vicar or any of his family was travelling! The parsonage was sold many years ago. There were some plans to convert it into a pub, but it was thought to be somewhat insensitive, so the parsonage was converted to a bank. In time the bank moved, and the site is now landscaped.

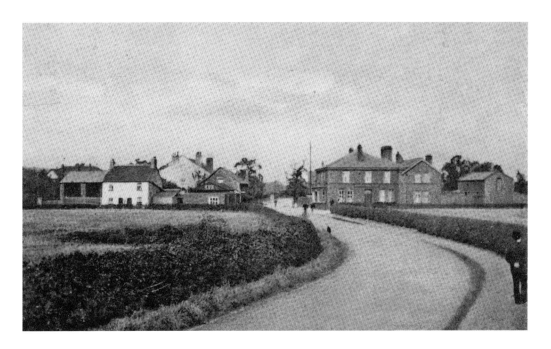

The crossroads at Hunts Cross have always been important. The earlier view shows the Hunts Cross Hotel, which stood for many years, before it was knocked down and a new retail area built. Obviously, the telephone exchange, which can be seen on the left of the more recent shot, hasn't been there quite as long as the crossroads.

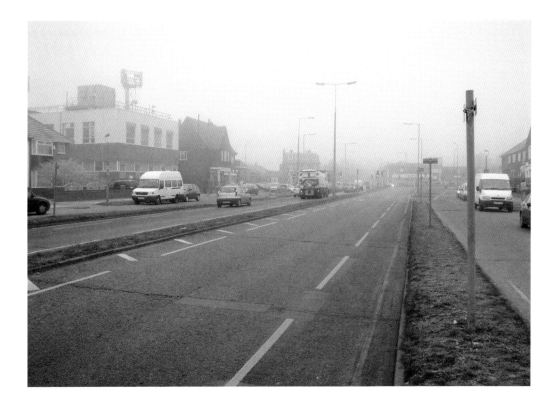

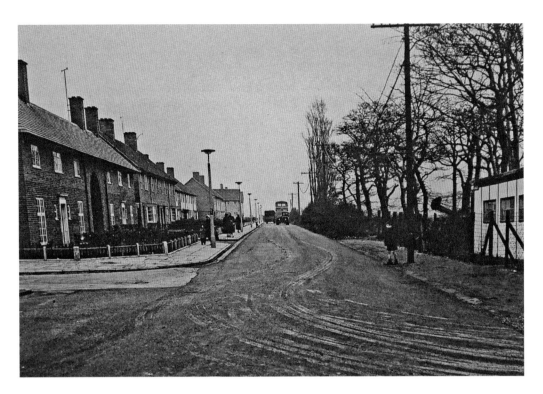

Buses started to run along Hale Road as soon as the new Eastern Avenue was completed. This was the 'new' part of Speke. Houses on the far side of the Central Shopping Parade were known colloquially as 'new' Speke, although some of the residents in the original village had a different understanding of 'new'. The road now marks the current limit of the airport estate – but, like Topsy, the airport continues to expand in all directions, so who knows where it will be in another fifty years?

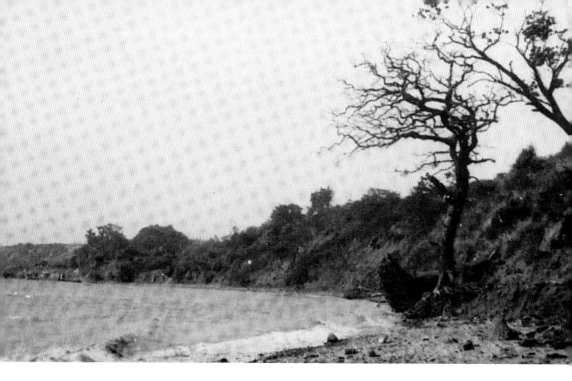

The shore line at the bottom of Dungeon Lane looks much the same now as it did over one hundred years ago, but much has changed since that time. In days now long since gone, women carried baskets of freshly caught shrimps to be sold at Garston market just a few miles away over the fields. People walking along the shore now are more often than not walking their dogs or bird watching. There are no shrimp pickers now!

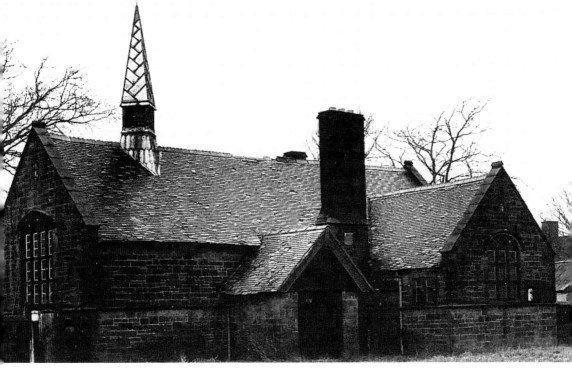

All Saints church hall has stood on the same site since anyone can remember. Leonard Rossiter of 'Rising Damp' fame started his acting career here; and, so the story goes, Paul McCartney was in the 16th Allerton Scout Group which held their meetings in the hall.

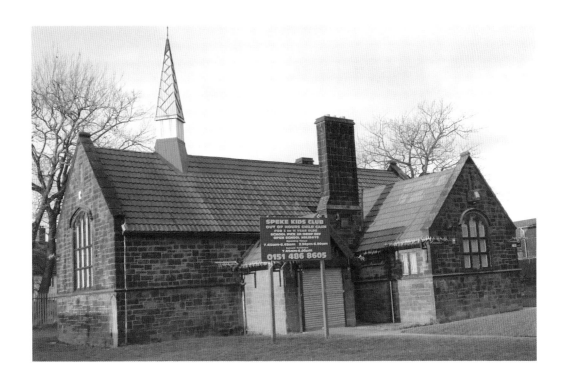

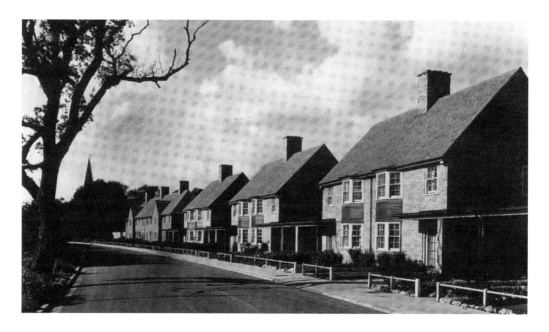

Hale Road was one of the first roads to be built in Speke after the end of the Second World War. The original plans, which had been drawn up well before the war, envisaged a much grander concept, but austerity and economics changed that vision. Hale Road today is similar in many respects to what it was in the early '50s.

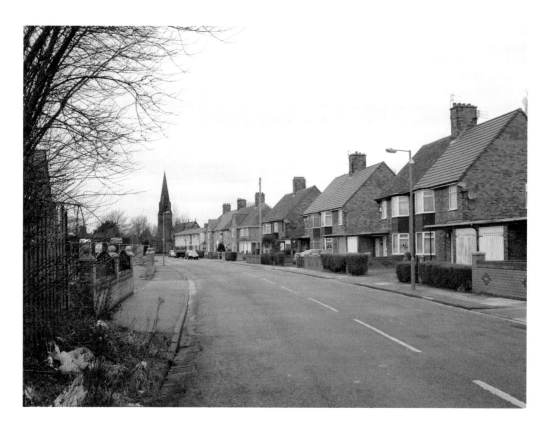

A new sign for the Childe of Hale public house was commissioned and erected in September 1929. Now, eighty years later, the pub is still a lively meeting place, but the sign has long gone.

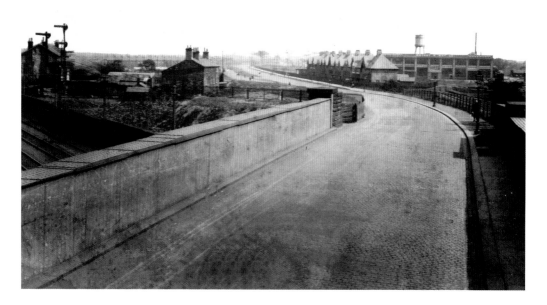

Long before any alterations were made to this bridge, this was the view looking towards Speke. In the left foreground, just over the bridge, Chapel Farm can be seen. On the right is the match works owned by Bryant and May. The workers' houses, built in 1926, can be seen just in front of the factory itself.

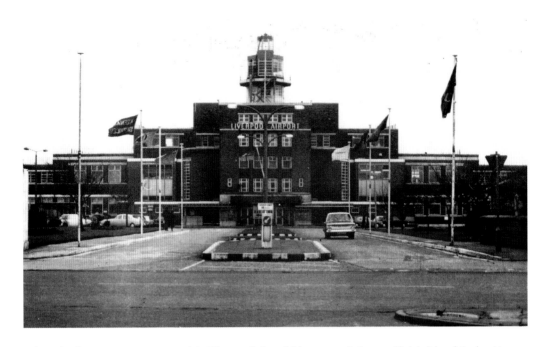

When the first airport was opened in Liverpool, it quickly assumed the unofficial title of Speke Airport, although civic pride never acknowledged this. When jet travel arrived, it was found that the runway was far too short, so a new runway was constructed which, in turn, necessitated a new terminal building. The new airport is called John Lennon Airport, Liverpool. The old terminal building is however still in use as a popular hotel and restaurant.

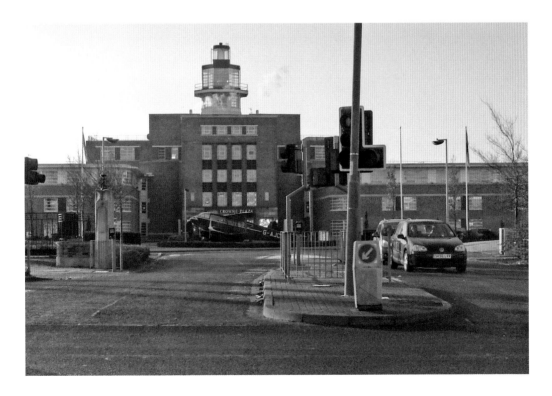

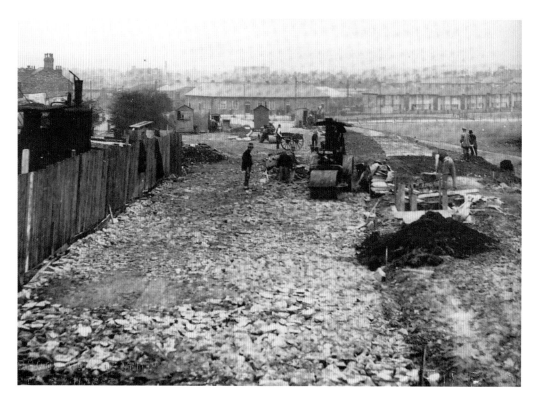

Work began on the Speke Road Bridge in September 1921. At that time, Horrocks Avenue, named after Jeremiah Horrocks, the great astronomer, who was born in Toxteth, could be seen in the background. Today the view is taken by PC World which is perhaps somewhat ironical.

In 1951 the road into Speke from Hale was certainly much quieter than it is today; but the same houses are still standing and the road is still just as narrow.

They built some very impressive houses at the junction of Dam Wood Road and Lovel Road. The houses are still much the same today as they were some fifty years ago, and, quite remarkably, some of the original railings can be seen just behind the lamppost.

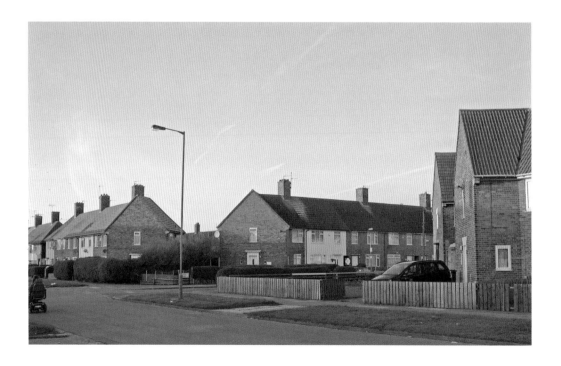

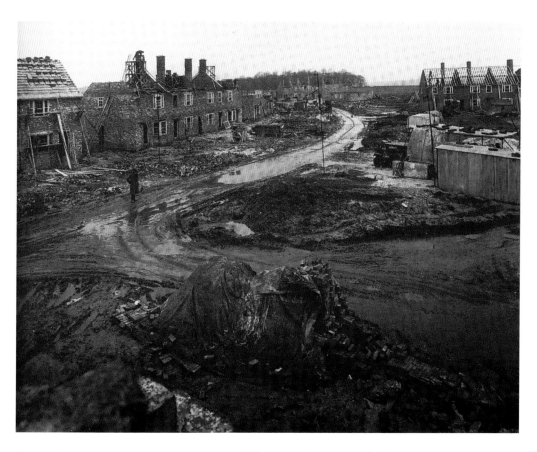

Once work got started, progress was very rapid. The houses here are on the far side of Eastern Avenue at the very extremities of Speke. They're still the last houses before going out into the village of Hale.

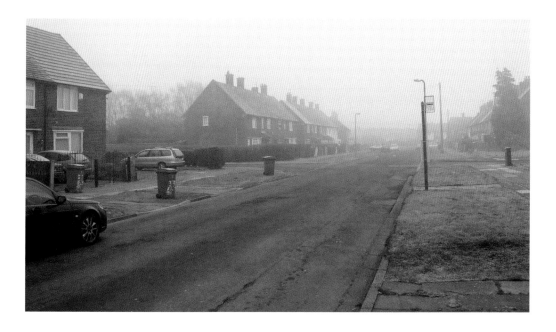

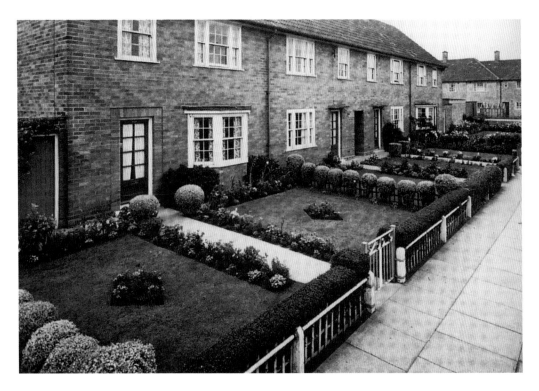

When Speke first emerged as a housing estate in its own right, several clubs and societies were formed. The gardening club was one of the strongest, and competition was fierce when judging day came in the annual garden competition. In 1958 nos 149-155 won the collective prize for the best kept group of gardens. The gardens are still neat and tidy today, but an element of keen competition is now missing.

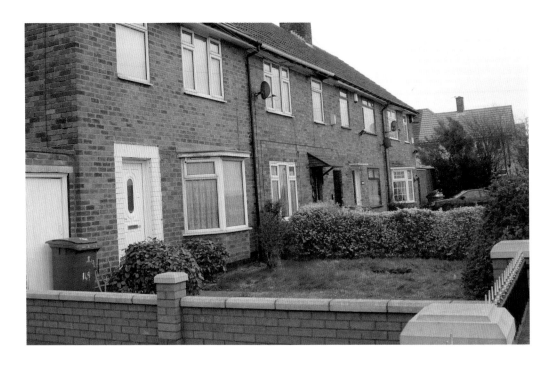

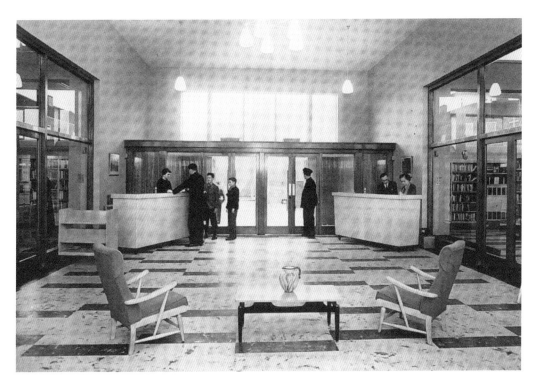

After the initial surge to get the infra-structure and most of the houses built, attention focused on building some social amenities, such as schools, churches, shops, swimming baths and a new library. Speke Central Library was opened in October 1956, but now there's a new library in Speke, so the site is well used as an all-purpose crèche and nursery.

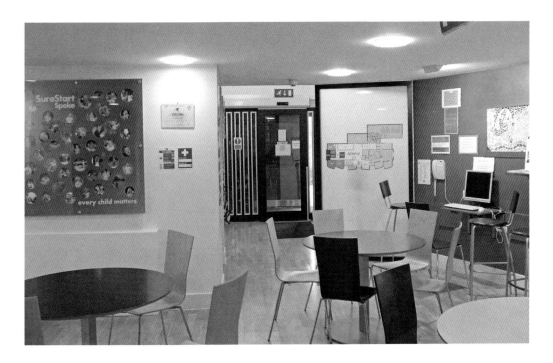

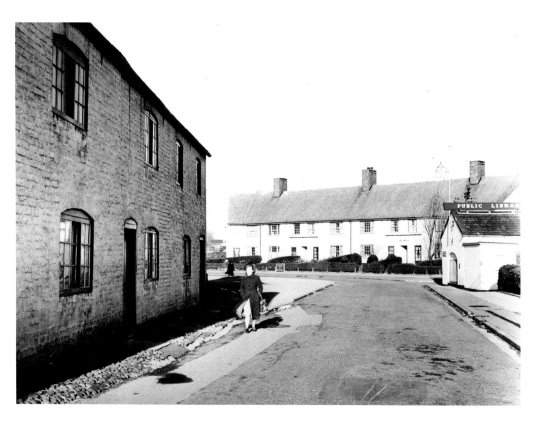

Some of the cottages in Speke Town Lane were still standing, well after many of the new houses had been built. The temporary library had now been moved to the old smithy, and the estate was beginning to become more established. When the cottages were eventually demolished, a new shopping centre was built on the site.

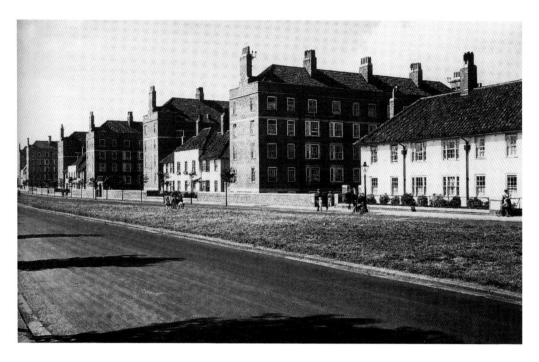

The tenements, known as Speke Hall Gardens, were built in 1932. Sometime earlier the site was occupied by Cowen's nursery, and before that the vineyard owned by Mr Meredith. The grapes were highly sought, and were enjoyed by, amongst others, Queen Victoria and the Pope. But that was a long time ago. The tenements have long gone, and new houses built.

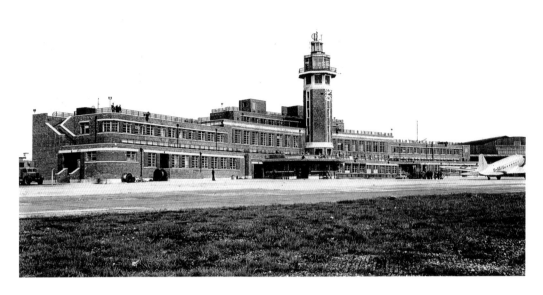

Viewed from the far side of the apron, the old terminal building still has that certain something! When the Beatles came back from the States the place was absolutely crowded.

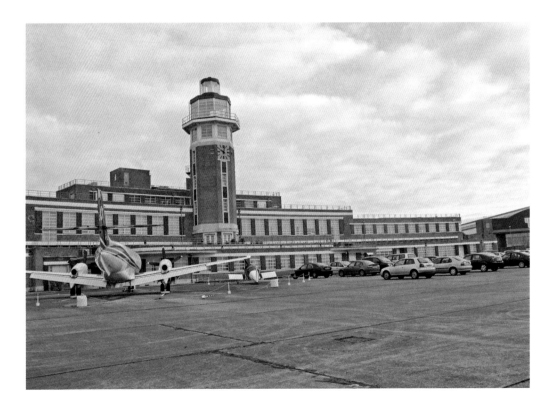

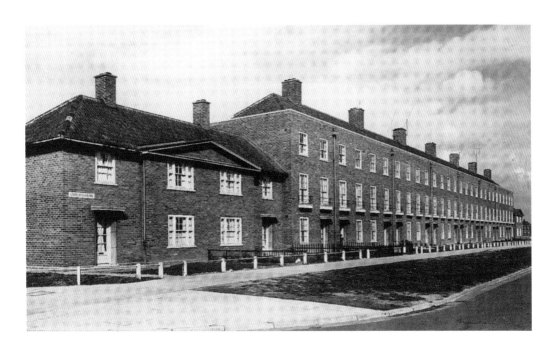

Houses in Stapleton Avenue followed the broad concept of housing in Speke, with houses being built to meet different perceived social and family needs. But, with changing needs, many of the three-storey houses have now been re-modelled to become two-storey family homes.

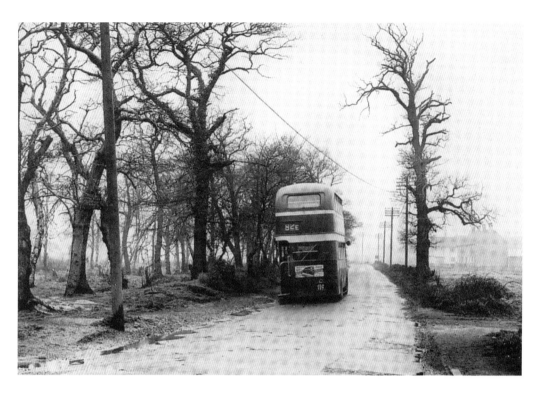

It was many years before the houses at the far end of Speke, towards Hale, were completed. But, as soon as Eastern Avenue was constructed, buses started to go along Hale Road and then make the return trip towards Western Avenue and then onto Garston and Liverpool. The road is now, effectively, the perimeter road of the new John Lennon Airport.

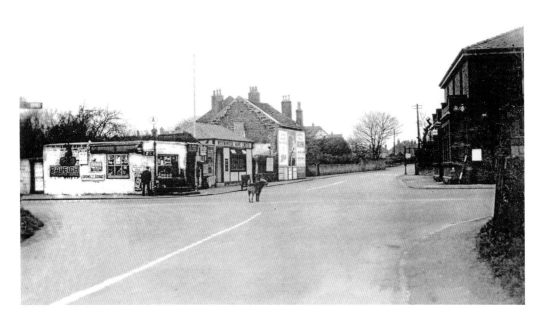

The old Hunts Cross Hotel can be seen on the right with the sandstone cross, railed off, near to the bystander on the left. A stray dog would not stand much chance crossing the road in today's heavy traffic!

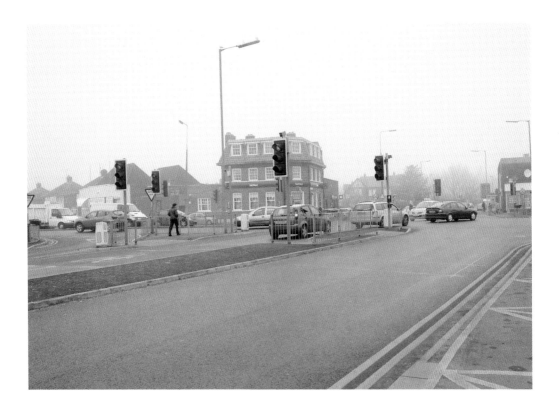

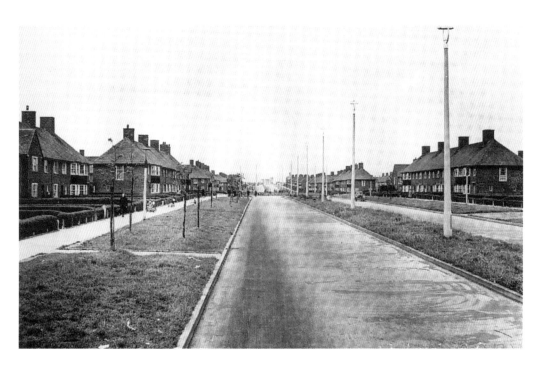

The Pegasus public house was built at the bottom of Western Avenue after the houses had been completed, and, for many years, proved a popular meeting place. The pub has now been demolished to make way for new buildings and hotels necessitated by the insatiable appetite for land which John Lennon Airport generates.

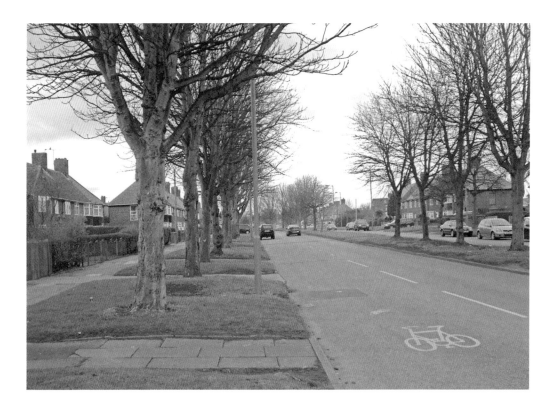

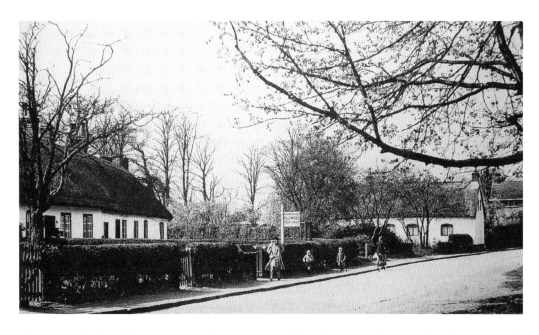

The cottages in Church End have stood there since the middle of the sixteenth century. The first photograph was taken on 13th November 1934, but, as can be seen, Church End remains very much the same today as it was in 1934 – some seventy-five years ago!

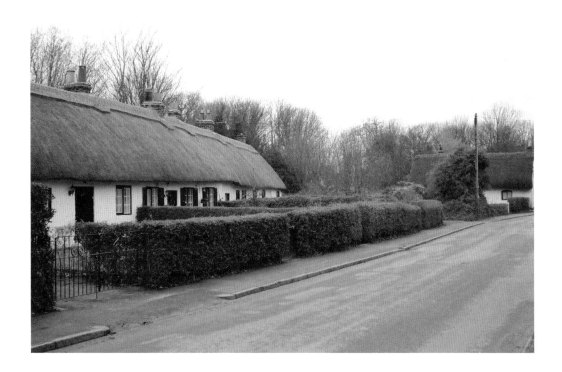

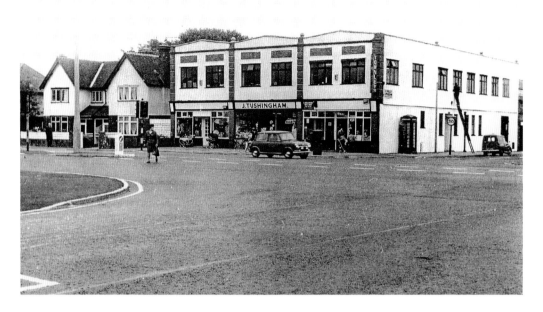

The Tushingham family played a significant role in the development of Hunts Cross. Not only did the family build many of the houses in the area, they also established a prosperous brick-works in the near vicinity. The shops on the corner of Mackets Lane and Higher Road, which were owned by the Tushingham family, have now made way for residential properties.

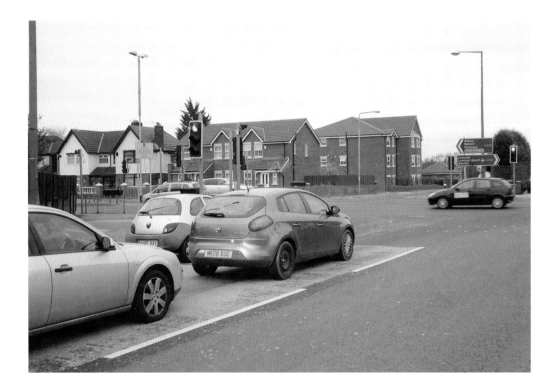

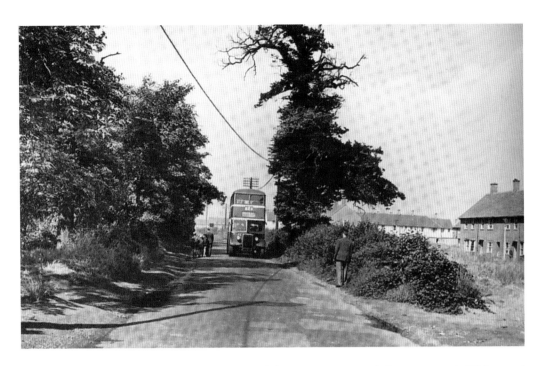

Crosville buses had been going down Hale Road for many years on their way towards Widnes and Warrington, but it was some time before Liverpool corporation buses ventured down that road. They turned off at Eastern Avenue and made their way to the new bus terminus at the far end of Eastern Avenue.

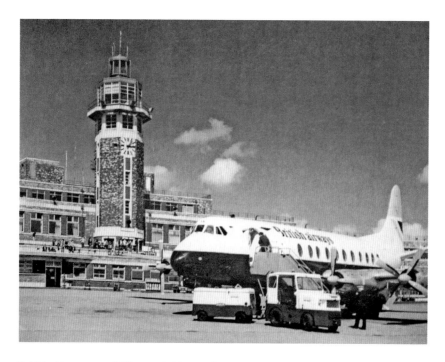

British Airways used Liverpool Airport for many years after the Second World War. Mostly, the airport catered for domestic flights, but, with the advent of package holidays, more flights went to continental destinations.

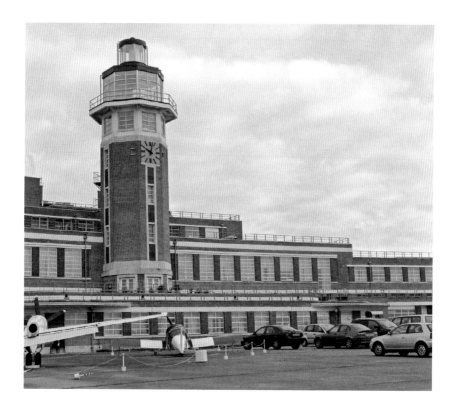

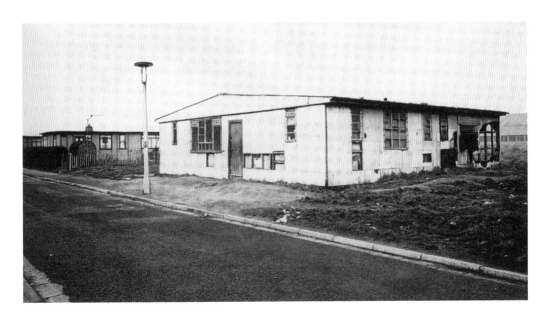

Speke had its fair share of pre-fabricated houses, or 'prefabs' as they were known colloquially. The main prefabs were in Rycot Road, but there were others in the same area of the estate. The prefabs are no longer in evidence, and much, but not all, of the area is now landscaped.

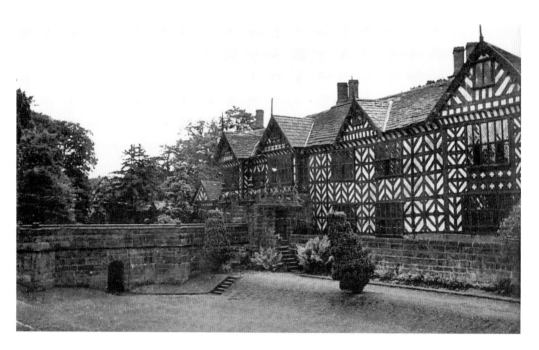

Speke Hall is recorded in the Domesday Book of 1086, and by 1200 the tenure of the manor of Speke was held by the Molyneux family. Many alterations have been made to the hall since that time. Miss Adelaide Watt was the last owner of the hall, which was then passed to the National Trust in 1943.

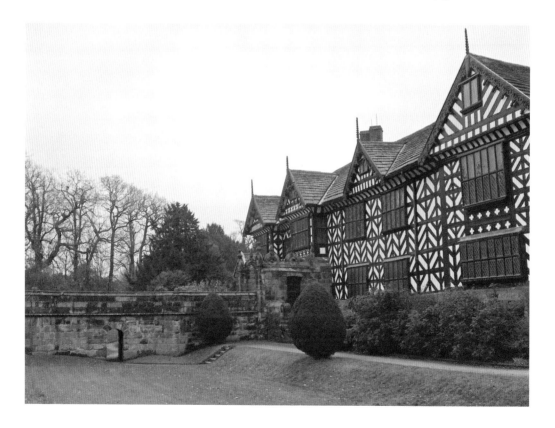

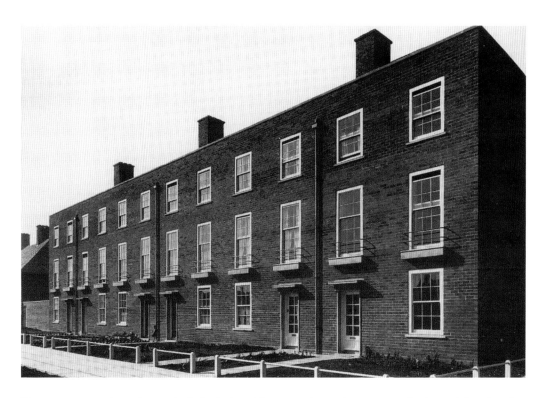

There were many large houses built in Speke; this was an integral component in the social engineering approach being taken by the city council. But, since that time, plans and policies have been re-assessed, and many of the three-storey houses have now been converted to two-storey dwellings.

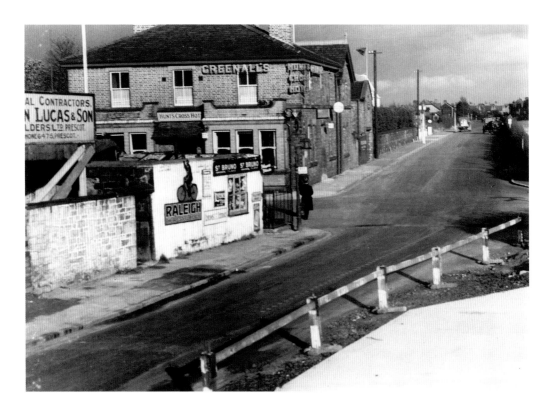

The Hunts Cross Hotel was a hostelry which many people called at when stopping at the village. The hotel was near to the main railway station, so there were always people in there during licensing hours. The original hotel is no longer there, but a new hotel has been built just behind the new shopping arcade, and it's every bit as popular.

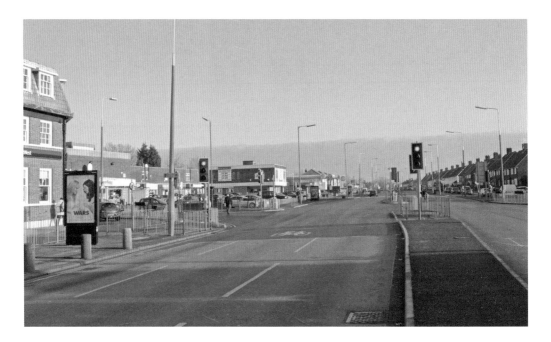

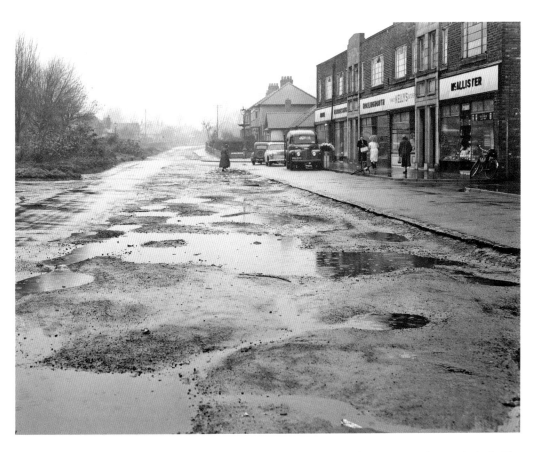

As Hunts Cross developed, it soon became obvious that there was a need for some new shops to be built. The shops at the top of Mackets Lane are still there, but there is a very different way of retailing these days.

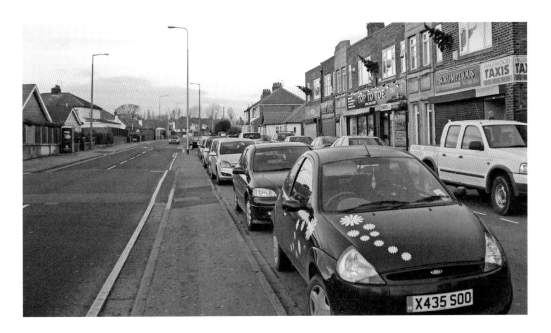

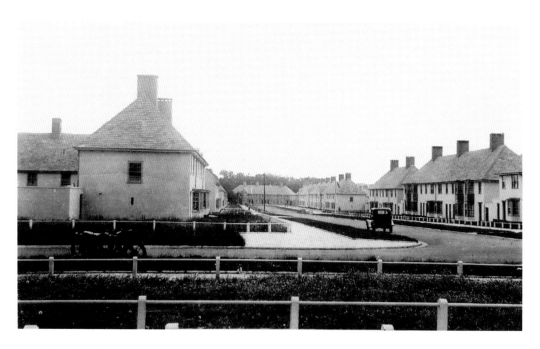

Once the plans for the beginning of the Speke estate had been passed, and the necessary infra-structure roads and sewerage completed, work started on the houses themselves. Gerneth Road was one of the very first roads to be completed on the new estate.

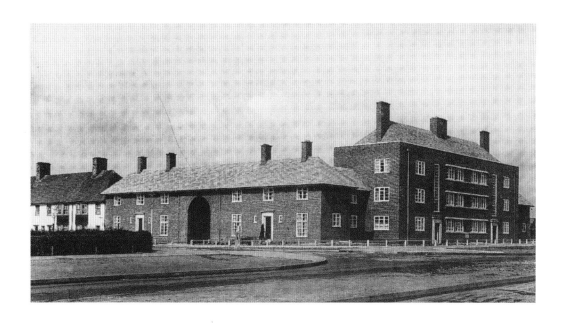

The social engineering experiment is once more evident here, at the cross of Bray Road and Western Avenue. Much of the original concept remains here.

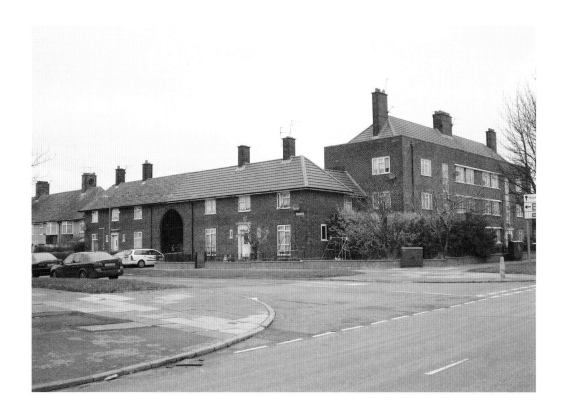

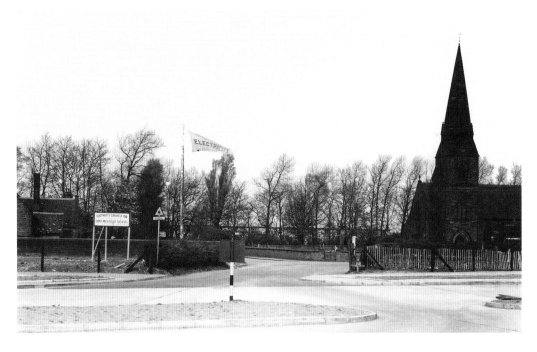

Residents of Speke were actively urged to use as much electricity as possible, as the banner clearly shows. Since that time, and the proliferation of different electricity suppliers, the usage and sale of electricity is marketed in a completely different way, thus allowing the church hall to revert to other uses.

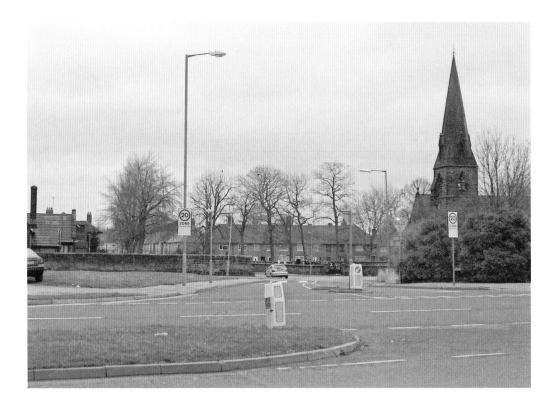

Travelling through the village of Hale towards Speke, it is necessary to negotiate the war memorial triangle. Hale Hall was situated in the grounds behind the house which can be seen in the photographs. The hall is no longer there, but Hale Park provides a much-used leisure facility for the residents of Hale.

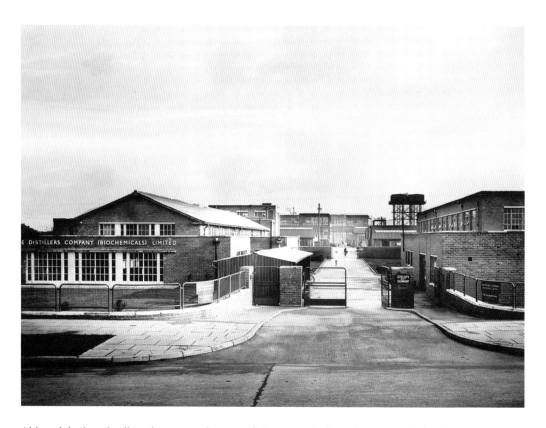

Although built and still used as a manufacturer of pharmaceutical products, part of Eli Lilly's was used, for many years, as a school building for children from Speke. Obviously, this was before local schools had been built for the many children who moved to Speke with their families directly after the Second World War.

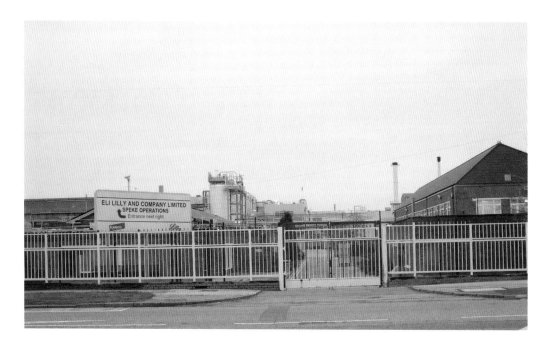

After Woodend Lane became dual carriageway, its name also changed to Woodend Avenue. Many manufacturing concerns had premises along the road, there being a ready supply of labour from the surrounding area. Industries thrived until the mid 90s, when there was a reduction in the manufacturing base. Since that time, much of the new build has been apartments and small office blocks.

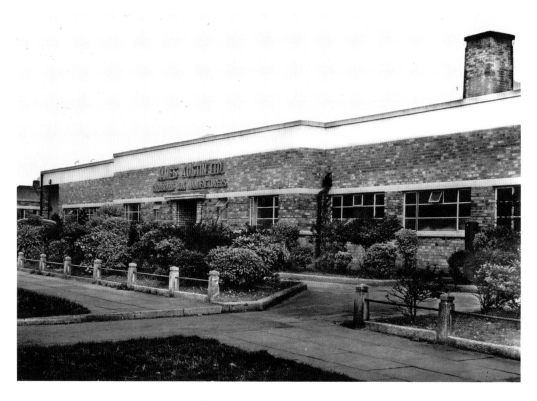

James Austin Ltd, were makers of cardboard boxes, and had their manufacturing premises along Speke Hall Road. There was great demand for cardboard boxes immediately after the Second World War and the company thrived. Later, the premises was converted to a training centre, and more recently, the site itself was cleared to make way for new enterprise.

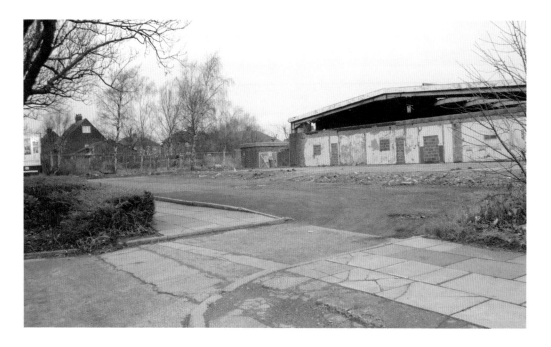

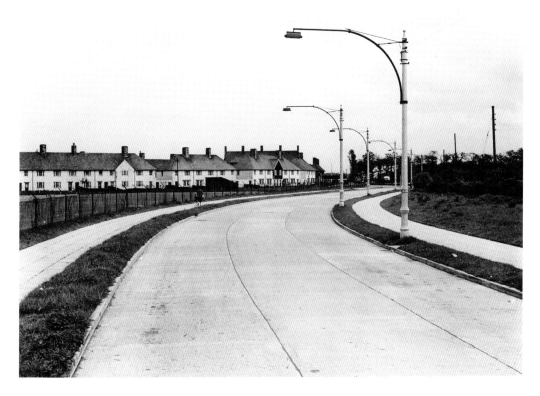

Dunlop Road was a fairly obvious name for a road with one of the biggest tyre manufacturing factories in Europe at the end of it; but, Dunlops is no longer there or any evidence that it ever was! The area where the factory stood now services, in the main, the ever increasing needs of John Lennon Airport

Dodds Lane, as it used to be called, linked Speke with Garston. During the Second World War special lighting was used along this road, so that the airport, which was bounded by the road, would not be visible to enemy aircraft. In more recent years, a retail park has been built between Speke and Garston, so the road is busier now than it has ever been.

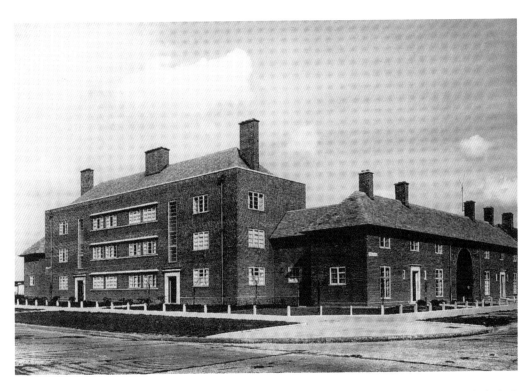

Many ideas were floated when Speke was first conceived, and social engineering was a particularly high priority. For that reason many different types of dwelling houses were built. The houses are still very much in evidence, but the social planning appears to have slipped down the list of priorities.

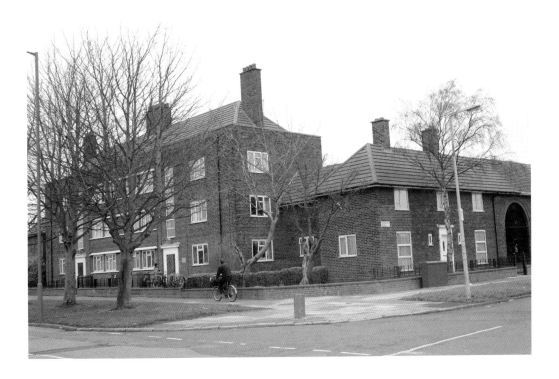

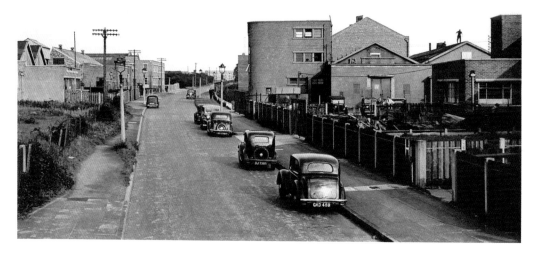

There was a good manufacturing base around the environs of Speke, with many small to medium sized enterprises opening there after the Second World War. In 1946, Edwards Lane was home to many manufacturing companies. The world famous Meccano sets were manufactured in Edwards Lane.

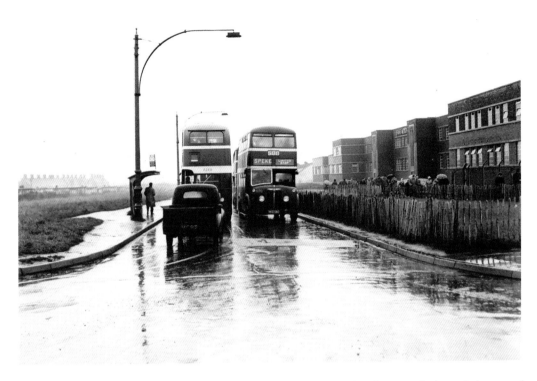

Public transport, and in particular corporation buses, were the conduit between Speke and the rest of Liverpool. Buses brought workers into the estate every morning from all over the city. Similarly, residents of Speke were able to travel, via the frequent bus services, to all parts of Liverpool and beyond. The 500 bus, which was a 'limited stop' service, halved the travel time between Speke and the centre of Liverpool; but, it did cost considerably more to travel on this service.

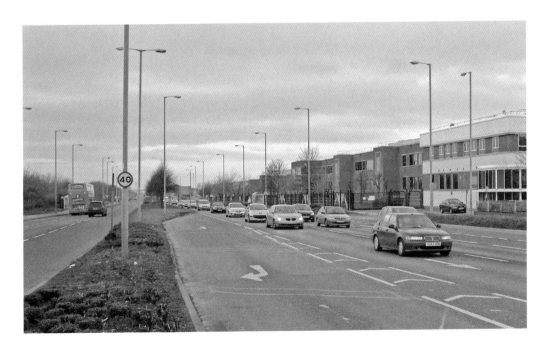

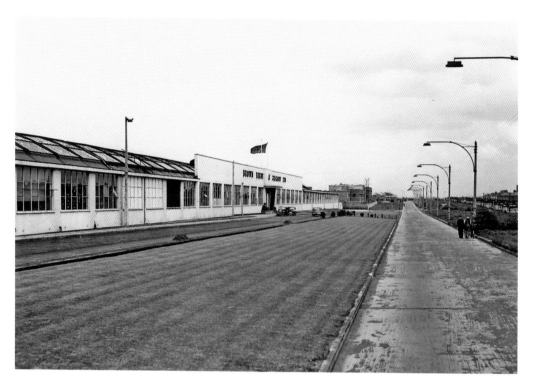

One of the largest manufacturers of cardboard goods opened premises along Speke Boulevard. Brown, Bibby & Gregory employed many highly skilled printers and other tradesmen.

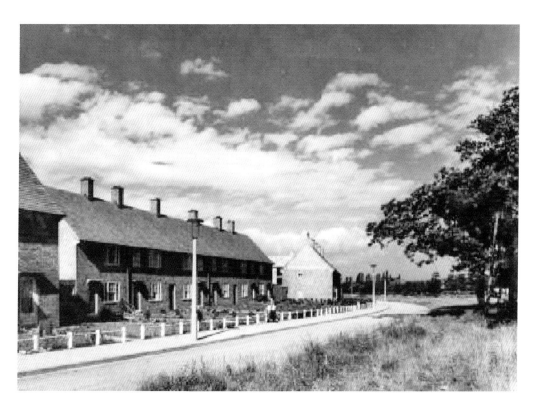

Alderfield Drive was built at the 'new' end of Speke, and was one of the roads which was completed much later in the building programme. Many of the houses are now owned privately, as can be seen from the roofs. The corporation replaced the roof tiling on all of the properties which they still owned, but privately owned properties did not have their roofs re-tiled.

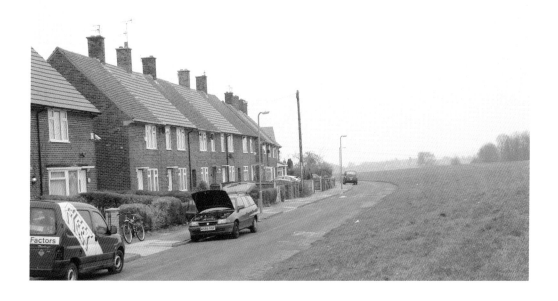

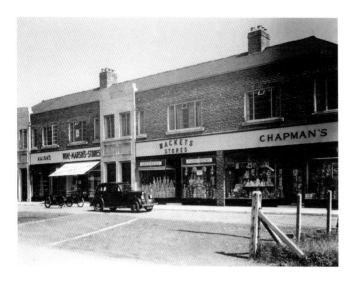

None of the original shops that were trading at the top of Mackets Lane are located there today, but the block of shops is still very busy catering for everyday shopping needs.

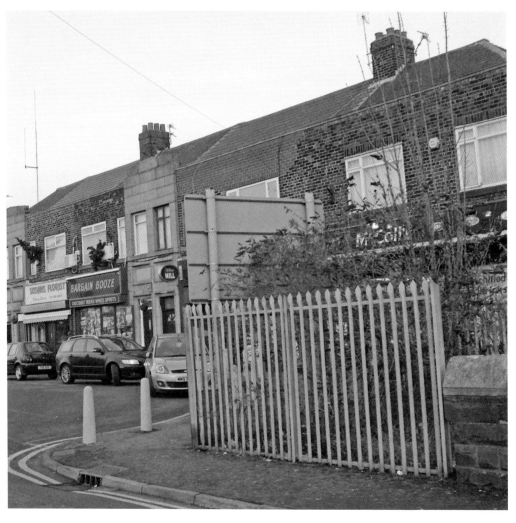

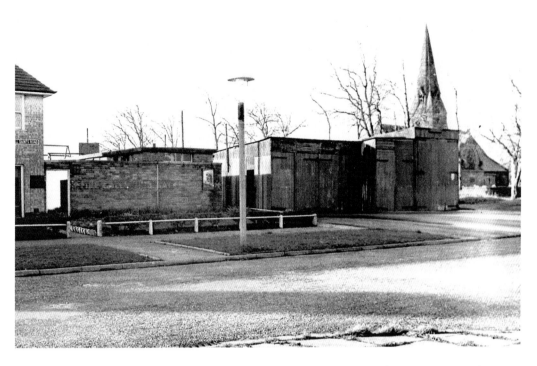

When the Speke housing estate was being built it was important to ensure that emergency services were available. A temporary fire station was housed in accommodation near to All Saints church. Later on a completely new fire station was built nearer to the centre of the estate.

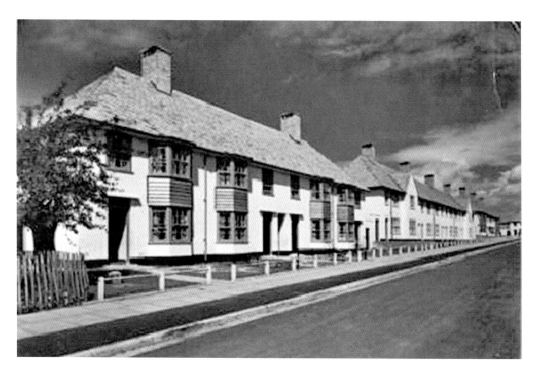

School Way is another of the very first roads to be built on the new Speke Estate. Again, although there are far more private cars around these days, the road is still very much as it was in the '50s.

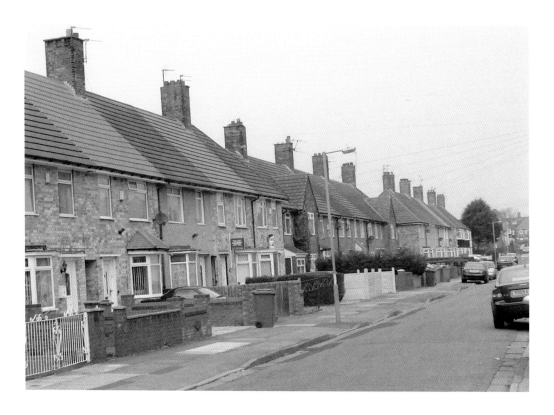

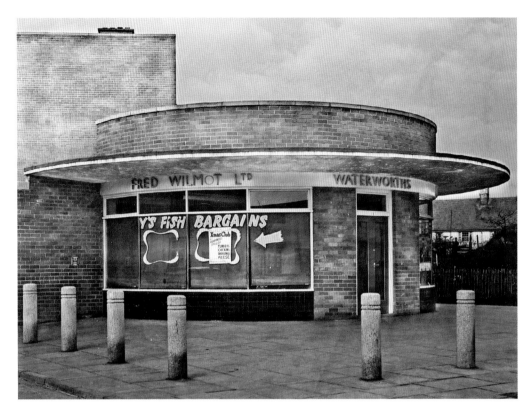

The end shop on the Crescent was Waterworths, a local greengrocery company. Up until the time that the Crescent was built, local residents had to rely on the mobile shops coming around the estate. In fact, mobile shops were a constant feature on the streets of Speke well into the mid '50s.

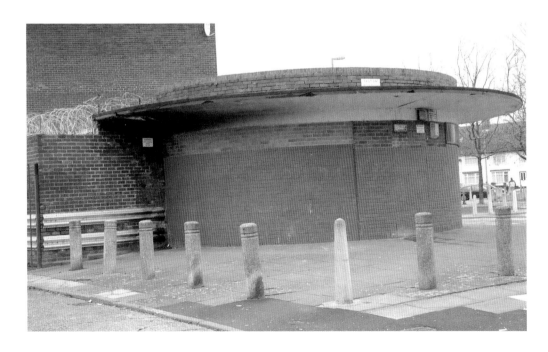

Once Woodend Lane was changed to a dual carriageway, travelling between Speke and Hunts Cross was much easier. It was also an ideal area for manufacturing companies to become established.

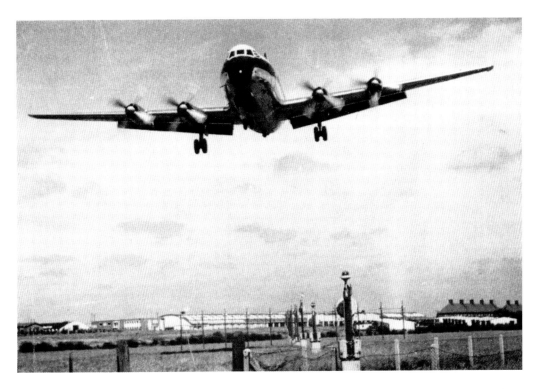

Brown & Bibby's, (Brown, Bibby & Gregory), later known as Metal Box, was directly under the flight path for landings at Speke Airport. There are still a couple of Vickers Viscounts which land at John Lennon Airport, but turboprops have long since been replaced by Boeing jets.

The doctor's surgery was located in the first house after the shops at the centre of Hunts Cross. The surgery itself was held in the garage which had been suitably converted. There is now a new purpose-built surgery on the far side of the road.

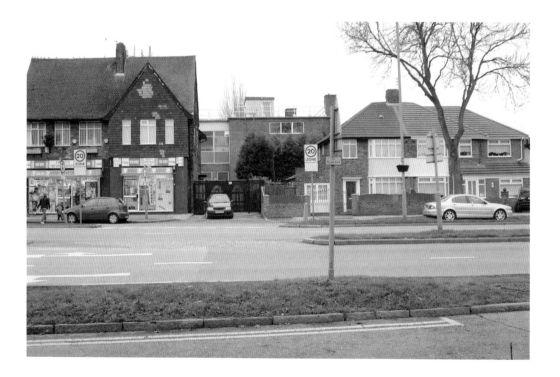

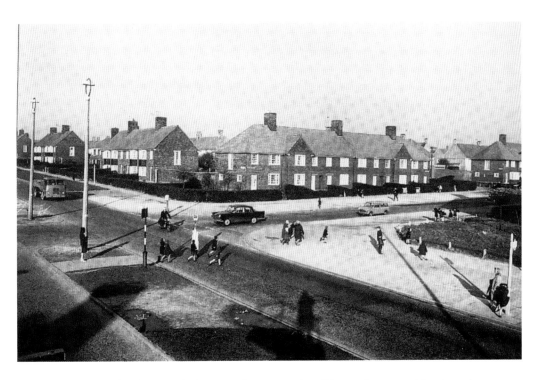

During the morning, lunchtime and afternoon, the crossroads at Western Avenue and Stapleton Avenue was very busy with children going to and from school at Stockton Wood School. There's a new school there now, but the crossroads isn't quite as busy these days.

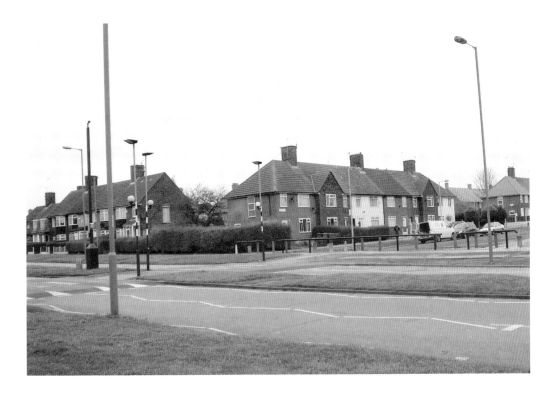

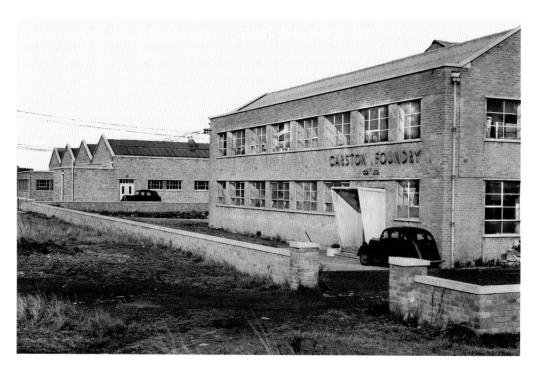

Over the years, the factory that was built as Garston Foundry, has passed through many owners. Currently, it's a Beds/Furniture factory and showroom, but that sector of the market is experiencing the same difficulties as many other manufacturers and retailers in the area.

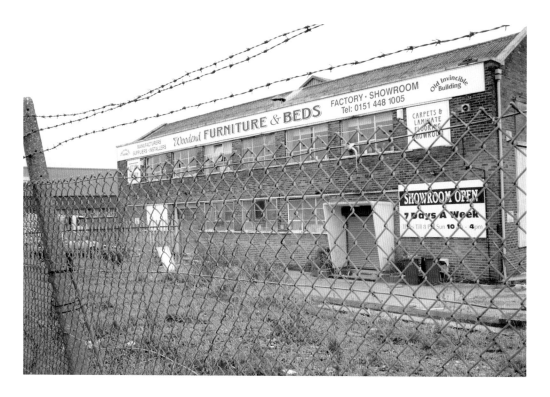

Because of increasing use of Hale Road, it was decided to re-surface the road. By this time, many buses and other traffic used the road. Today, much of the traffic is heading for John Lennon Airport.

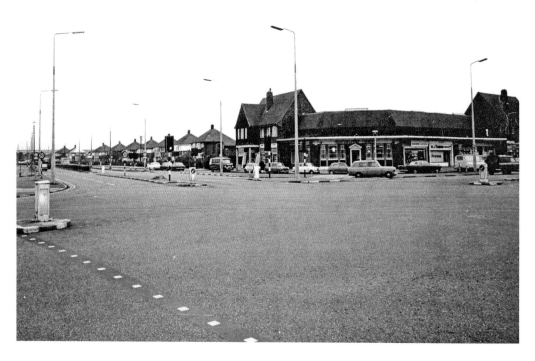

The cross roads and the shops at the centre of Hunts Cross were always very busy, and, with the growing population in the area, they became very much one of the social centres of the village.

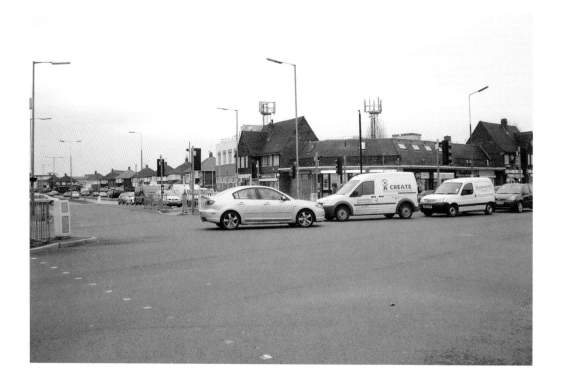

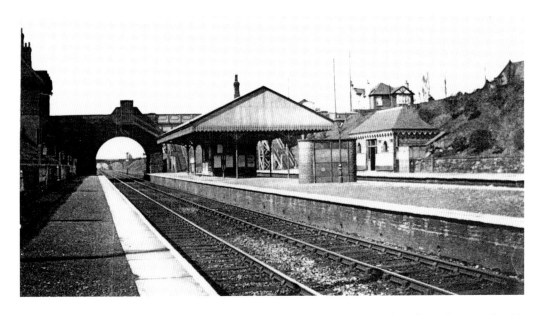

The railway station at Hunts Cross was originally opened in May 1874, but then after considerable modification to create four tracks, the newly expanded station was re-opened in 1883. The station is still one of the principal stops for Manchester-bound expresses.

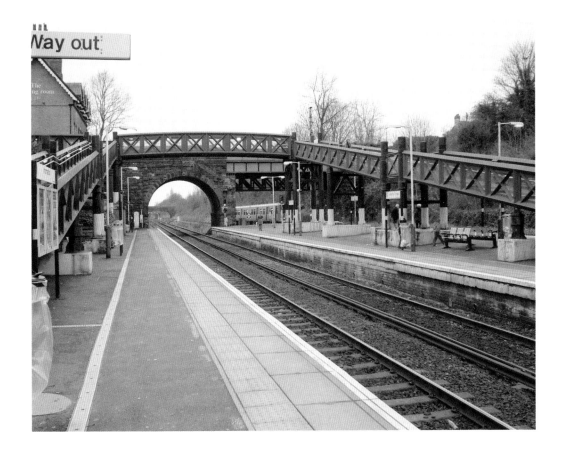

It was a very quiet area when this photograph of All Saints church was taken in 1926. Since that time, the village of Speke has been transformed into the Speke estate, and also, the main access road for John Lennon Airport runs not too far from the side of the church.

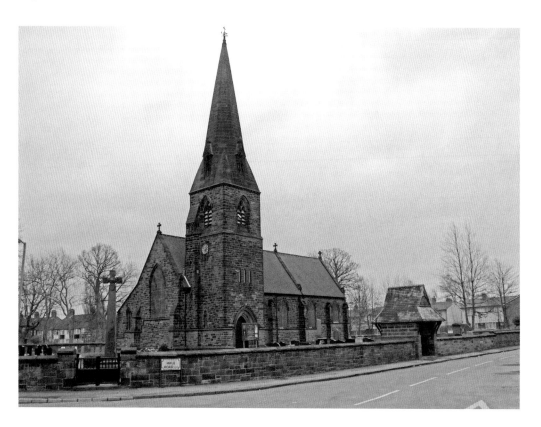

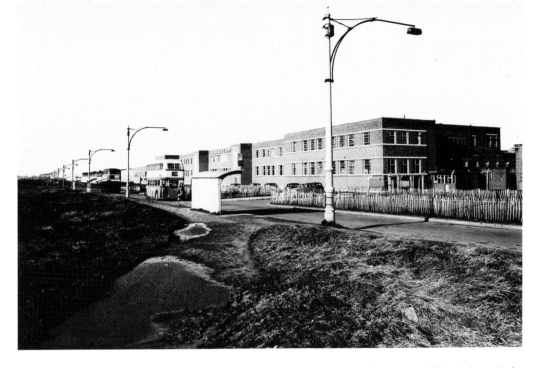

Evans Medical was one of the very first manufacturing companies to become established along Speke Boulevard. The company specialised in pharmaceutical research and manufacture. During the war years, many social attitudes to female labour changed, which was reflected in the fact that the workforce at Evans was predominantly female.

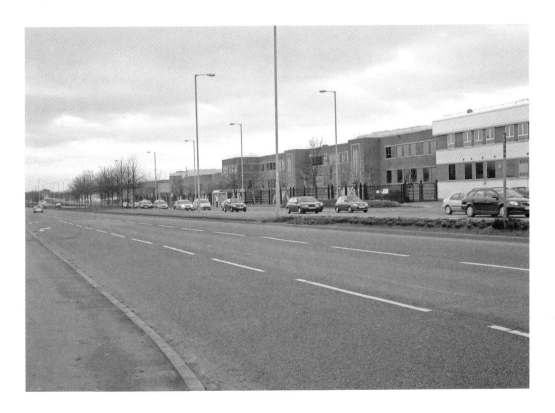

Liverpool education authority was very much in favour of comprehensive education when it was introduced in the mid-sixties, and was one of the first authorities to build purpose-built schools. Speke had a number of large comprehensive schools; Central Avenue school being one of the main ones. But, with demographic changes and changing educational priorities, the school, as such, became redundant.

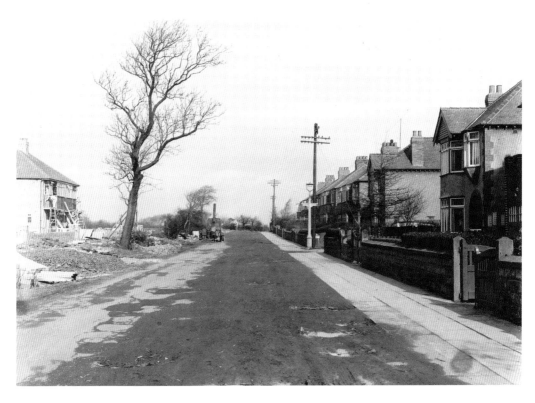

It was very muddy underfoot during construction of the houses along Mackets Lane. But the road soon became established as one of the most popular in the area – a title it can still boast about!

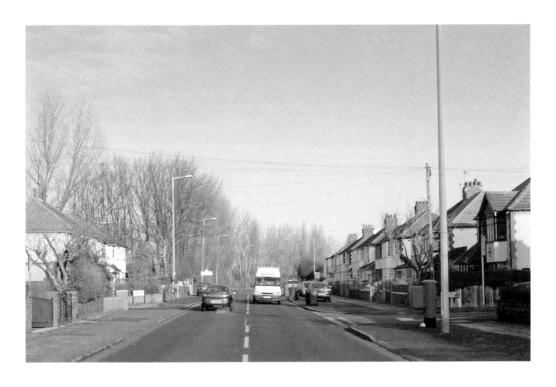

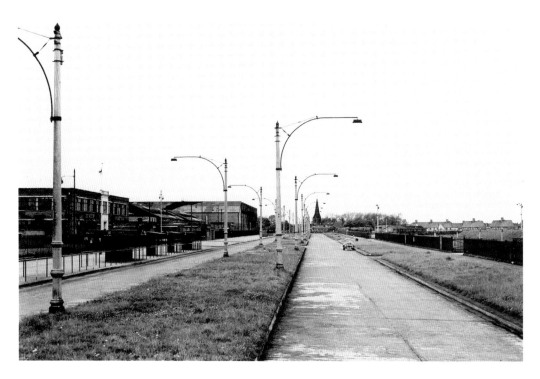

One of the largest employers in the area was Dunlops. The factory, which employed over two thousand people at one time, manufactured rubber tyres of every size, from small tyres for Minis, right up to the very largest tyres for earth moving equipment. During the Second World War the factory was used as an aircraft assembly plant. Today there is some light industry on the site and also service facilities for the nearby John Lennon Airport.

The density of traffic along Higher Road and Speke Hall Road soon meant that a massive roundabout needed to be built to assist the flow of traffic. However, with today's traffic, and the nearby Asda superstore, there is still a lot of traffic congestion, and that's even with an elaborate system of integrated traffic lights!

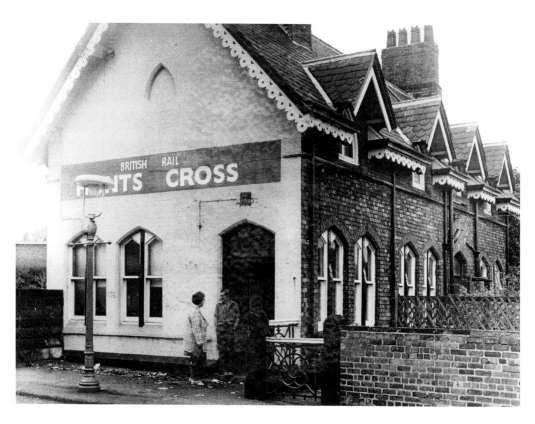

The original station building at Hunts Cross served for many years. But, following the introduction of the electrified line, a more modern station building was erected, and the original building put to good use for other purposes.

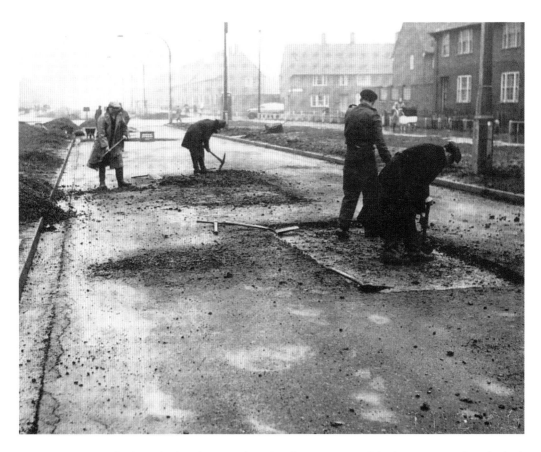

Eastern Avenue, at the far end of Speke towards Hale village, was one of the last major roads to be built on the new estate. However, shortly after the road had been opened, a major fault in the basic construction was discovered, and the road had to have significant remedial work carried out in February 1954.

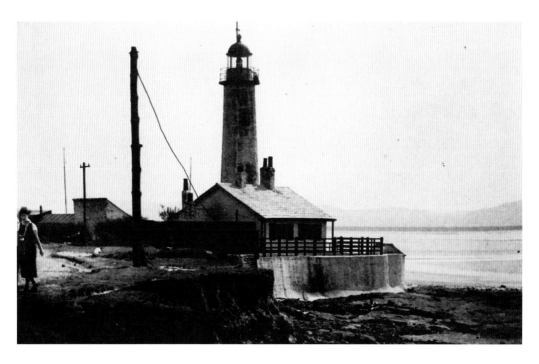

Hale lighthouse stands at Hale head, which is the widest part of the River Mersey, at almost three miles across. Because of its width, the river is also very shallow at this point, which causes some treacherous currents. Before the transporter Bridge was built at Widnes, this was the main crossing point to Weston in Cheshire. The Hale Ford crossing, as it was known, was used until well into the nineteenth century.

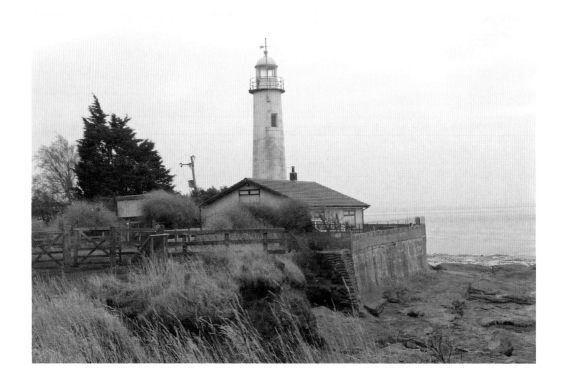

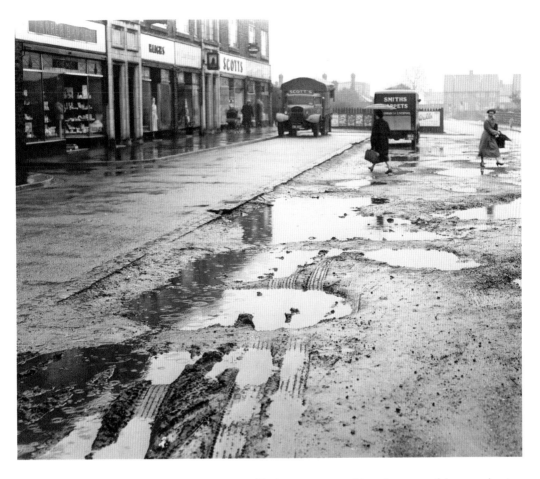

The shops at the end of Mackets Lane were opened in August 1936, and have been one of the central points of the village ever since.

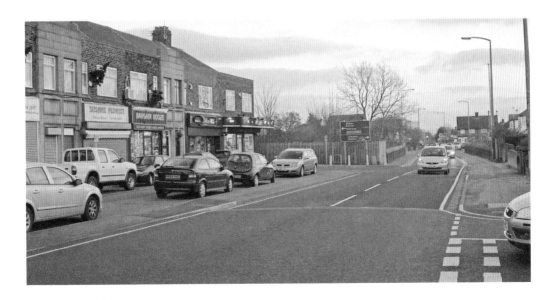

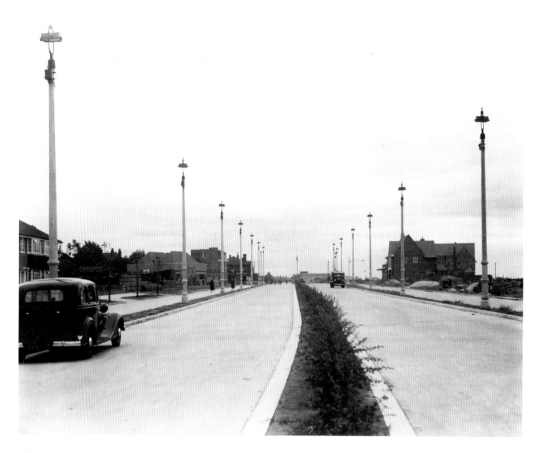

The sweep on Hillfoot Avenue is still the same today as when the road was constructed, but the traffic is very different.

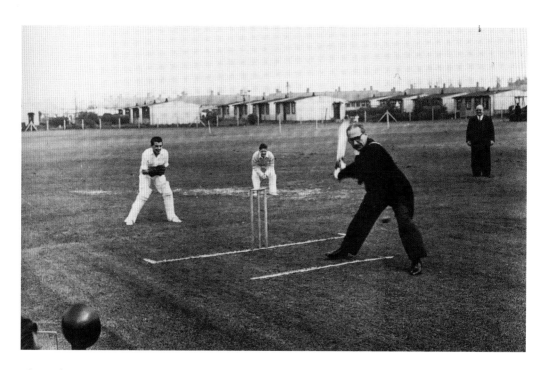

The Speke Recreation Ground was opened by the Lord Mayor of Liverpool in 1958, and was very well used for almost fifty years. But, with changing times and different patterns of social activity, the ground fell into disuse.

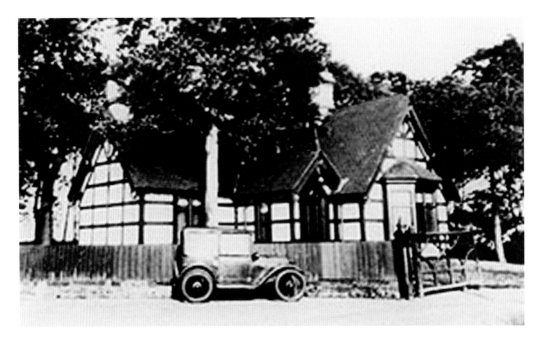

This is the North Lodge at Speke Hall, and thankfully, it still stands today. If you visit the Hall, you will see the Lodge on your left as you pass through the main gates. This photograph appears to have been taken sometime during the 1920s.

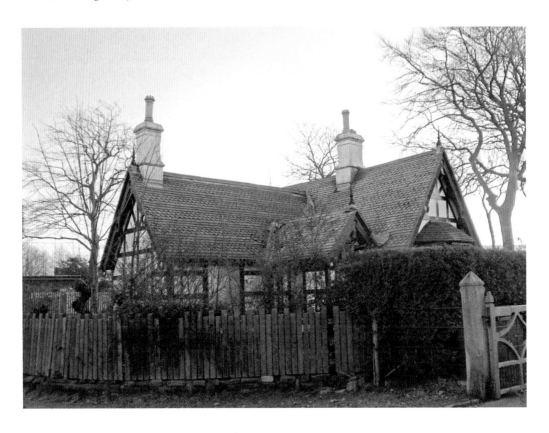

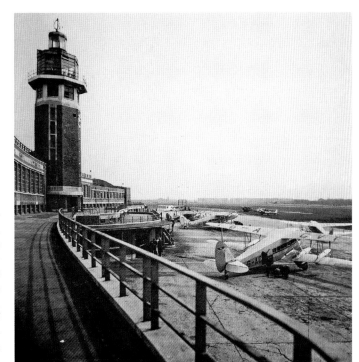

Liverpool Airport looked very different in 1946 when this photograph was taken. The De Havilland aircraft in the foreground were the most popular aircraft using the airport at that time, although there was a fair number of larger planes which landed – normally the Vickers Viscounts owned by British Airways.

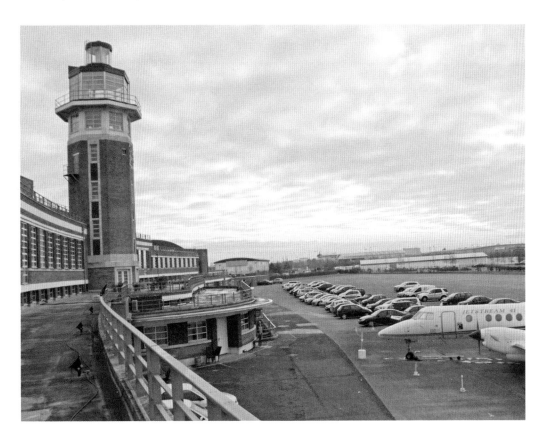